Share Your Skills

The ultimate guide to running an art or craft workshop

Dr Rie Natalenko

The Write Impression Publications

Text copyright © 2015 Dr Rie Natalenko

ISBN 978-0-9941732-3-2

For Bob, who has always supported me and who gave up his snooker room so I could have a craft studio. A sign of true love.

Thanks to everyone who helped me to put this book together. Thanks for your suggestions and support, and an especial thanks to Julia Kuris, who did such a great job with the cover.

Table of Contents

5

Why share your skills?

There are many talented artists and craftspeople who should be sharing their skills!

Many art and craft practitioners are **experts** in their field, but **don't understand fully** the skills required to run classes, workshops or coaching sessions.

It's true. We've all been to workshops, paid good money, and been disappointed because they weren't taught well.

In this era of instant social media, people will hear about the workshop immediately. Participants will share on Facebook and Twitter and Pinterest if a workshop is amazing ... and if it isn't.

So what are the secrets of a good workshop? How can you be sure that you're doing the best that you can for your students?

The good news is that it isn't rocket science. Good workshops take work – of course they do – but it's not at all difficult to learn.

Some people look at me and say, "but Rie has a Masters degree in training teachers and a doctorate in Creative arts." That just

allows me to pick out the really important bits and pass them on. Plenty of people have been able to run excellent workshops without any formal qualifications at all. As my husband, Bob, says, "It isn't rocket surgery!"

I've helped many people in the arts and crafts fields to start their own workshops, and become successful, and I can help you, too.

This book is a great introduction to running workshops to share your skills, and it will give you all you need to know to make your workshops awesome.

Of course, I can't **guarantee** that your workshops will be amazing. I can't possibly know what sort of person you are, and how you will use the information. What I can promise, is: this is the information which I've shared with other tutors and workshop leaders, and it's lifted their workshops from ordinary to exceptional.

In this book, we'll cover:

- The advantages of running workshops
- What you do before a workshop
- What you do in a workshop
- What you do after a workshop
- A section on students
- A section on business
- Resources

Let's get started!

The advantages of running a workshop

It seems that more and more people are running workshops to share their skills with the world, and maybe you have thought about doing it, but have decided against it.

There are several categories of objections, however, so I thought I'd address each sort separately.

The first category of objections looks like this:

- I don't have anything interesting to teach.
- I don't know enough.
- I don't feel secure enough in my practice to run a workshop.
- There are better workshops out there.
- Nobody would come.
- I don't know enough about running workshops.
- It's too much work to organise.

These are what I call "confidence" objections. This is what people

say if they are feeling insecure, and I am overjoyed to tell you that if your objection is in that list, or if you have an objection that sounds like something in that list, then this book can overcome that objection.

I can show you how to select what you can teach, to ensure that it will be interesting for your students. I can give you the confidence to realise that you do know enough. I can help you to improve your workshops so that there aren't better ones out there. I can show you how to market, how to run the workshop smoothly and how to organise it in the simplest way.

The second type are "social" objections:

- I don't like talking to people.
- I don't want to share what I know.
- I can't be bothered - I don't have the energy, motivation.
- I don't see the benefit to me from running a workshop.

If your objection is one of the first two, you have set me a difficult job to overcome that objection. If it's shyness, I can show you the tricks to overcome that shyness.

If it's a genuine dislike of people, then maybe running workshops is not for you. I once went to a workshop which was run by someone who came across as disliking her students. I didn't learn much, and it was probably a waste of other students' time, too.

I can't promise to fire you with enthusiasm, either. I can show you how easy it is to share your skills, and that might help, but I can't overcome the lethargy with which some people live their lives.

If you can't see the benefits of running a workshop, then read the rest of this chapter before you give up. There are benefits – real benefits – to running workshops, and in so many areas of your life.

Another type of objection includes "physical" objections.

- I don't have the space.
- I don't have the time.
- I don't need extra money.
- I don't need extra exposure.

If you don't have the space, you can hire a space.

Time is something which you might be able to find if you think that the benefits of running workshops outweigh something else which is taking up your time.

If you don't need the money, that's wonderful – but it may not be the only reason that you should be sharing your skills.

If you feel that you aren't in need of extra exposure because you're either famous enough, or really don't want to be, then it could be that what you are really afraid of is the insidious "competition" objection.

- I don't want to create competition.

Sharing your skills may mean that you might lose future sales to someone else. It's something that you really do need to consider. Maybe others will think that they can make similar things – and if they do, they might become your competition.

If this is a serious problem for you, you could still share your

techniques and inspire and encourage your students to interpret those techniques using their own skill base and creativity.

So why bother to run workshops?

Sharing your skills is like planting a seed in a garden. You show the students the techniques, but then stand back and watch them grow, watch them develop and be proud of them.

Sharing your skills is sharing what you love. It's helping others to experience the joy that you experience when you sew or bead or felt or spin or paint or whatever makes you excited.

Many art and craft practitioners make the decision to run a workshop. There are some more obvious benefits in running a workshop, but there are some less obvious ones as well.

Of course, some people would never dream of running a workshop. Their techniques are sacred and secret, and never to be passed on.

So what *are* the benefits to you, the practitioner, of holding a workshop?

Running a workshop can impact your "artistic bottom line" in a positive way because of a number of factors.

Economic benefits

This is one of the more obvious benefits to you – you can make money. Workshops can bring in extra income, as can weekly classes. You can run workshops in your studio, or in a local hall, or for community groups in their halls, and all of these will bring in

14

some income.

Running workshops is often preferable to other forms of non-art-related income-producing options because you are still working within the boundaries of your artistic practice. You are earning money as a direct result of your art.

You can sometimes do a deal with the suppliers of your mediums, too – so your students can purchase supplies through you. This will bring in even more money.

If you run workshops in your studio, the students will also see your art work around, and may even purchase some themselves or for presents, especially around holiday times, so the economic benefits of workshops speak for themselves.

Physical benefits

Workshops are an easy way to make people aware of your work. People see your work, tell others about it, and spread the word. Workshops don't really require huge commitments of time or energy or preparation or overheads. Don't get me wrong. They are not, despite what some tutors think, walk-in-walk-out with not much in between. They do require **some** time, energy, preparation and overheads, –especially the first time – but not as much as some other activities such as opening a shop, or holding an exhibition, for example.

Social benefits

Arts and crafts practitioners are typically solitary. They often work

in isolation, and, let's face it, this can be lonely. Workshops allow you to interact in a group – a group where everyone is interested in the same thing, and that thing is your work! How cool is that?

What is more, you are the one who is facilitating this great gathering of kindred spirits. You are sharing your skills with them. This makes you the hero, the altruistic leader. Workshops are generally extremely friendly gatherings, and the participants – and the workshop facilitator – all enjoy them.

Psychological benefits

This leads me to the psychological benefits of running workshops. Workshops, if well planned, usually are very successful. The students leave with your praises on their lips as they admire their creations. This is very, very good for the ego.

Those students go off and tell other people about your great workshop. They tweet about it, mention it on facebook and put up pictures of their creations, and they thank you each time for teaching them. And the people who read those posts see your name, and your good reputation as a person, and as an artist, grows. It makes you feel good. It's a morale booster.

Even seeing how much your students are learning can boost your morale and your sense of self-worth. A successful workshop could be worth a hundred visits to the psychologist!

Credibility benefits

Simply running a workshop boosts your artistic credibility. If

people weren't sure before about how good you are, they will be now. I mean, only those who are good practitioners run workshops, right? I can hear your doubts about yourself seeping into cyberspace, but everyone started from nothing at one time, and look at everyone else now!

When your students start to rave about your class, that is a boost in credibility. Sometimes you just have to have enough faith to put yourself out there, and then everyone else will reflect that faith back to you.

Publicity benefits

When you publicise your workshop you are publicising yourself and your art. When your students tell others that they are going to your workshop, they are giving you free publicity. When they post their achievements on social media sites, talk about the workshop, tell their friends how much they enjoyed it, they are giving you and your work publicity which is worth its weight in gold.

Creativity benefits

Finally, if you run a workshop, you force yourself to analyse the way you work, because you will be passing your knowledge on. This results in a quantum leap in your own skills. It is true what they say – if you really want to learn something, teach it. You refine and define your skills in whatever area you will be teaching.

Also, if you are very wise, you will listen to your students. Often they are just as creative as you. Often they have skills or

17

techniques that you can learn as you watch them. The wise teacher learns all they can from their students.

So, with so many benefits from running workshops, why not give them a go?

I am often asked, "Have you ever run a craft or art workshop, Rie?" I know what they mean. Do I teach painting or textile craft or beadmaking or any of the other "crafts" I enjoy. The answer is, "yes." I have shared my felting skills in community workshops and on cruise ships. My main "sharing" is that I teach writing, and that is as much of an art or a craft as any of the other things I enjoy.

I have also been to tens, if not hundreds, of workshops over my many years of dabbling, and I remember some of them with joy, and others with horror.

I am a trained teacher, but I also have a Masters degree in teacher training. And I have a Masters and a Doctorate in Creative Arts. I have somewhat, as Jeanne Robertson says, "over-degreed myself."

I've taught in high schools, TAFE, Uni and in many community workshops and online. I've taught one-on-one, small groups, large groups, on cruise ships – everything up to huge lecture theatres full of students. It has been my life.

Over the years, many of my artist and craft-practitioner friends have asked me questions about teaching – how to plan a good workshop, how to decide what to teach, how to structure a workshop, how to change your teaching style to suit adults, how to handle difficult students, etc, etc.

There didn't seem to be much out there to answer those questions specifically for those of us who want to share craft or

artistic skills. So I put a course together, I've written this book, I give talks, guest blog for websites – and answer the list of questions as to how to best share your skills.

The rest of the book addresses those answers – what to do before, during and after a workshop, with a section on student learning styles, a section on the business side of things, and a really useful resources section.

I look at what to do before the workshop:

- Understanding why people attend workshops
- What is the optimum number of students?
- What level workshop should it be?
- The 90/10 rule
- Objectives
- Dividing up the time
- Notes for students
- Physically setting up the workshop
- Checklists
- Plan Early
- Food etc…

I discuss what makes for a good workshop:

Content

- Knowing your stuff
- What to put in and what to leave out
- What to do when you don't know something

Running the workshop

- The beginning
- Train like a train
- Tips and tricks for teaching

- Ending the class
- Photographing/ videoing the class
- Leveraging your work

I help you with what to do after a workshop:

- Self evaluation
- Feedback forms and testimonials
- Evaluation and change

There is a short overview of students' learning styles.

There is a discussion about the business side of workshops:

- Pricing
- Legals
- Sales and marketing
- Types of workshop
- Venue
- Ethical issues
- Other business options

Finally, there is a section of resources, checklists and templates which are invaluable when it comes to running workshops.

Are you ready?

I suppose you have to ask yourself, before you start, whether you are ready to run a workshop.

Ask yourself these questions:

- *Do I have a sense of commitment to the students?*
- *Do I have the drive to achieve?*
- *Am I reasonably optimistic?*

- *Am I in control of my emotions?*
- *Do I know what my strengths and weaknesses are?*
- *Can I learn from experience?*
- *Am I open to feedback?*
- *Do I have a sense of humour?*
- *Can I listen well?*
- *Can I give others feedback?*
- *Can I identify what others need?*
- *Can I relate well to different people?*
- *Can I persuade people?*
- *Can I inspire people?*
- *Can I guide people?*
- *Can I lead by example?*
- *Can I promote a friendly and cooperative group?*
- *Do I like helping people?*
- *Can I fake it if I'm not confident?*
- *Do I want to share my skills with the world?*

If you answered, "yes" to most of these, you'll be fine!

If there are some that you answered, "no!" to, chances are that the solution is in this book.

The basic skills you need to run any sort of workshop are:

- Empathy
- Social competence
- Leadership

The final skill that you need is Confidence.

Lots of people don't feel confident, but it's because they don't feel prepared. The more you are prepared, the more competent you feel, and the more competent you are the more confident you are.

These two feelings, competence and confidence feed back into each other so that, as one grows, so does the other.

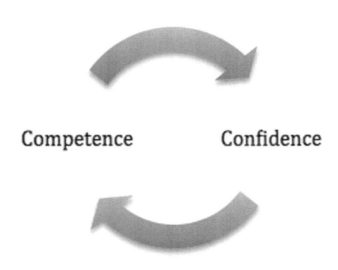

Competence Confidence

The more experience you get, the more confident you feel, and the more confident you are, the better you perform.

So the more prepared you are, the more confident you are. That's what this book is all about – preparing you so you can be confident.

Read the book, go through all the suggestions and pick the ones that you think will work for you.

If you do that, you will be well prepared to run a workshop.

What to do before a workshop

If you plan a workshop carefully, it will run more smoothly and you are less likely to forget something.

Content

The first thing you must decide is what you are going to teach. Obviously, the details of what you will be teaching depends on your expertise, but it is always a good thing for the students to have a completed project at the end, so confine your workshop to something that is manageable. This will provide your workshop with a definite focus and will help you to decide on the structure. It also gives the attendees a sense of achievement.

Make sure it is something that ALL participants can be successful doing.

Once you have decided on what the students will achieve in your workshop, make 3 lists.

1. What the students must know to complete the project.
2. What the students should know
3. What it would be nice for the students to know, but is not essential.

You know your stuff. Of course you do. You know far more than the students do. And there lies the problem. You know FAR more than you need to know for this workshop that you will be running.

There is something really annoying about attending a workshop where the tutor says,

"I wanted to tell you about blahblah, but I'm afraid we have run out of time."

Unless she is trying to get you to buy into her next workshop – and it is already planned and you can do that easily, this is very frustrating for students. They know that there is something important that they missed out on.

So what can you do?

You write down everything that you should cover in the workshop, and you divide this into "Must know," "Should know," and "Would be nice to know." These are what is in your three columns.

When you plan the content for the workshop, make sure you include the first list, and **most** of the second list. DO NOT MENTION the third list unless there is time at the end.

It makes it easier if you have done your homework, and you know your audience. For example, there's no need to teach the elements of felting, if all your class are expert felters!

You have to decide how much ground to cover and how long that will take. To do that you may need to find out about your students. We'll look at that in the next section. You may want to have a beginners' workshop and an advanced workshop. You may decide to make a whole series of workshops. This is the time to do that.

Many tutors are tempted to try to include everything they know in a workshop. Some do it because they want to add value, some because they want to appear credible. Some do it because they want to appear superior to the students.

Whatever the reason, **don't do it**.

You will overload the students, and they will end up more confused than empowered. They'll think that you weren't a particularly good teacher, and they won't spread the good word about your workshops.

Only teach the things that are essential for the workshop.

Students

This workshop isn't about you. The most important people here are your students, and your job is simply to ensure that they get the most out of it that they can. Each person should leave your workshop having learned something valuable.

We have all been to workshops where there was a clear "teacher's pet." Some people know how to 'play' a teacher. Your job is to ensure that EVERY student learns, every student feels welcome, and every student benefits from the workshop.

Why are the students there?

Why do students attend art and craft workshops? It depends how the workshop has been advertised, and what you are offering.

Many students will have little or no experience with what you are offering. They may just want to relax and have a good time with their creative sides. Some may feel uncomfortable with art or craft and may want to increase their familiarity with it, to expand their comfort zone. Others may be planning to take up a hobby and want to try some different types of crafting before they finally decide. Experienced students will come if the technique is new to them, or it is something they have learned in the past and want to refresh their knowledge.

The value of workshops over more formal courses is that students can use the workshop as a "taster." They get a lot of individual attention and a lot of support. If you are a beginner, individual attention is very important – for self esteem, for creative growth and for technical problems you may have.

How many students?

How many students you want to take in a workshop will depend on several key factors:

• How much space do you have, and how much space will each person need?
• How much money do you need to cover your costs and make a decent return for your efforts?

If you have too few students, the workshop won't be economically viable. If you have too many, you may not be able to give each one the attention that they deserve and that they have paid for.

The size of the group will affect how you present the material. In a small group, you can be far more hands-on, while with a large group, you may have to think about a more telling-and-showing delivery.

In large groups (of fifteen or more students) it is hard to provide one-on-one attention. It is more likely to be successful if you combine lecturing with demonstration and then allow a practice session where the students get down to work. We will look at that in the section on teaching methods in this chapter.

So what is the optimum number? Most craft instructors say that for beginners, no more than 8. Some don't allow more than 6 in a beginners' workshop. If the students are more experienced, then perhaps the group could be larger, but that would depend on how complicated is the technique that you are planning to teach.

Who are your students?

You have to prepare for your students – who are they and how much do they know? Who they are, where they are up to in their practice, what they expect of you, their past experience, all this will impact on your presentation.

Some of the things that may affect the way you teach the workshop are:

• What is the age of participants? Children will need different teaching methods from adults.
• What gender are they? Most art and craft classes will be mostly women, but you might be surprised, and it does, of course, depend on the topic you are teaching in some instances.
• What is their cultural background? Do they all speak English?
• Do any have a disability that you will have to cater for?
• Do you know them? Or are they complete strangers?
• How much do they know?

- Are they complete beginners, do they already have some expertise – or is there a mixture of both?

Many people will call themselves "intermediate" because they don't want to be in a beginners' class, and they don't think they are all that good. However, they may not have good foundation skills, or they may just be being modest. Some have holes in their knowledge, and those holes are not necessarily the same holes that their neighbor has.

Mixed ability classes are the most challenging to teach.

When you plan a workshop, it is probably best to indicate what level of expertise it is suitable for. "Suitable for beginners or intermediate felters," or, "Some felting experience required," gives at least an indication to prospective students as to the level of familiarity with the craft they need.

If you run separate classes for beginners, intermediate and experienced students you can make sure that what you are teaching is suitable. You can encourage your beginners to learn more advanced skills as their experience and confidence level increases.

Attitudes: Why are they taking the class?

Some students are casual learners, "amateurs" who want to learn for the love of it. (The word 'Amateur' comes from the Latin word for 'love.') Some students, however, are commercial learners who want to learn the craft so they can make a living at it. They probably have different needs and interests.

You could run separate workshops for the different groups – and there are other niche groups you may want to think about.

What about running workshops suitable for corporate team building days? What about social occasions such as parties, where those attending already know each other? In groups like that you could focus on creating an atmosphere of fun and entertainment. Those attending such events might like to create craft gifts for family or friends for example.

If you are not sure about their knowledge and attitude towards learning before the class, you may need to change some of your teaching methods based on those factors as the class progresses.

What do you want them to learn?

Once you have decided what and who you want to teach, the next step is deciding exactly what you want them to achieve in the class.

An objective is like a goal for the class. What do you want them to walk away with?

For a beginners felting class, it might look like, "students will develop an understanding of felting, and will be able to make a simple felted scarf."

That objective says what the class is about – "developing an understanding of felting" and what the students will achieve – "making a simple felted scarf."

Objectives should be

- Measurable - you can measure whether it has been achieved or not.
- Observable – you can see whether it has been achieved or not.
- Understandable – students should be able to understand the objective. They should be specific.

There are other objectives that you might want to include, such as, "students will develop skills so that they feel confident enough to make a piece of felt on their own at home."

This is important, as it is often overlooked by tutors.

There are, of course, much bigger objectives, such as, "students will learn to engage with and love felting." You may not achieve this one in a single workshop, but you never know.

You will have to decide what the skills will be that are necessary to achieve your objectives, and you will have to include them in your teaching sequence.

Give your workshop a name

The name of your workshop should make it clear what you are teaching, and should be attractive to students (sexy, as they say these days.) Don't pick the first name that springs into your head. Think of a few names, then ask people who are your target audience which they prefer.

Teaching methods

Whole books have been written on different teaching methods, and I can't cover them all here, so I'm going to stick to the main ones that I've found useful and effective in art and craft workshops. When I say this, I refer to useful in my teaching practice when teaching writing or felting, and most effective when I was the learner.

First, make a list of the steps which will be needed to complete the task and achieve the objectives.

Your job is to get the students through each of those steps.

There are 3 main types of teaching which are of most use in the craft workshop:

- Explanation
- Demonstration
- Practice

Your main job is to work out what order to do these throughout the workshop.

Do you want to explain the whole technique, then demonstrate the whole thing, then have the students practise the whole thing?

Maybe you could explain the whole thing, demonstrate the first part, then have the students practise the first part. Then you could demonstrate the second part, have the students practise the second part, and so on.

Or maybe you will explain just the first part, then demonstrate it, then have the students practise it. Then you could do that with the second part, and so on.

That is called the sequencing of the tasks. You should think about which way of sequencing will best achieve your objectives.

Explaining

It is always good to involve the students in the explanation. Ask questions, use their knowledge, show them examples which they can pass around, get them to take notes or fill in a worksheet. If they are doing something more than listening, they will be learning more.

Demonstrating

While demonstrating, keep your students engaged. Again, ask them questions, get them to label diagrams, move them closer, make them laugh.

Practice

While the students are practising, what will you do? Will you circulate, helping one at a time? Do you wander around and only stop and advise if you feel it is necessary? You will have to decide what is best for your topic and your students in this regard.

The size of your class

Your methods may depend on the size of your class. If you have to teach a large number, then explanation and demonstration may be more appropriate than practice. Students may, however, still enjoy having a go at home and bringing in the completed items to the next workshop.

Breaking up the class into sections also works well for large groups. First, bring the group together for explanation and demonstration (which may have to be on a screen so filmed earlier.) Then allow the students to break off into smaller groups for individual or small-group practice (if you have enough room.)

Small groups allow you to be far more attentive to individual needs.

Demonstration is very effective because all can see clearly and ask questions as you go. You can explain as you demonstrate, if you feel up to it, then give personalised attention during the practice.

Individual lessons, or one-to-one coaching, is quite challenging.

For private lessons, the student guides the planning, because the lesson almost always follows their desires and needs. I find it easier to teach 2 people than one, simply because one-on-one becomes too intense, and people need to relax at times during a learning session, taking "mental time out."

Making the item along with the student, explaining and demonstrating and watching them do theirs at the same time often works really well.

Timing

Students need breaks, for morning and afternoon tea and lunch, for example. Think about these breaks as you plan your teaching.

Usually, half an hour for morning tea allows the students to get to know one another, an hour for lunch, and 20 minutes for afternoon tea is a good guideline. I allow 30 minutes for afternoon tea on my program, but if I'm running late, that's where I shorten.

When planning the workshop, estimate how long each section will be. That gives you a good idea of where to put the breaks.

It is a good rule of thumb to make the breaks closer together as the day goes on, so start with a longer session of teaching, and make the sessions shorter towards the end of the day.

Make a bullet-point list of everything that is going to happen in the class. Start with "students arrive" and finish with "saying goodbye".

Write how long you think every section will take. Then add some. It is important to overestimate how long everything will take.

Seriously.

Remember, you are showing someone something that they have never done before. They will take more time – a lot more time – than you do to complete it.

When and where will you run the workshop?

You should decide on a length, time and venue for your workshop.

You may have to research some venues and choose the most appropriate in terms of cost and space and access.

Think about:

- Size
- Space
- Furniture
- Comfort
- Ambience
- Is there plenty of space to display your own work?
- parking requirements,
- Public transport?
- How to pay them and when
- Insurance
- Will the venue help to promote the workshop?
- carrying equipment to the venue,
- accommodation for distant students,
- eating facilities if they are – or if they are not – to bring their own lunches.
- Is it wheelchair accessible if it needs to be?
- Are there decent toilets?
- Are there places for students to wash their hands?
- Is there a first aid kit?
- Is there a kitchen?

- Is the venue available when you need it?
- Is it affordable?
- Is there internet access if you need it?
- Is there phone reception?
- Who is responsible for cleaning afterwards?
- Are there enough powerpoints? Do they work?
- Are there desks/ workstations provided in the cost, and how many?
- Is there a projector/ screen/ whiteboard?
- Is there adequate lighting?
- If the workshop is to be over more than one day, can you leave the room set up?
- Is there adequate security?
- Storage for student's bags and coats?
- How do you get the key, and when and where do you return it?
- Are there security instructions to note?

There's a great checklist in the resources section at the end of the book.

Communicating with the students

A few weeks before the workshop, send information to the students as to

1. What they will need to bring:

- Materials (you may decide to provide everything yourself, or you may want the students to provide it.)
- Tools
- Food
- Anything else

2. What arrangements you will make for those unable to provide certain items on the day. For example, if you are running a glass

class that needs gas bottles, students who are flying in may need to make different arrangement from local students.

3. What time the workshop will start, what time it will finish.

4. Location of workshop and a map of how to get there.

5. Arrangements for payment

6. Ask them to label all their tools etc.

Student notes

Prepare any student notes necessary for the workshop. You may want the students to take their own notes, fill in worksheets, or you may provide a complete set of notes and instructions for your students to take away. You can make that decision based on the topic and the students.

The 90/10 rule

The most important thing that tutors MUST know about is preparation.

As educators, we learn what we call the 90/10 rule.

90% of your time is spent on preparation, and 10% on presentation. When you first give a workshop, you must expect to spend **at least** 9 times the duration of the workshop, in preparation.

I have met with incredulous stares from many practitioners when I have said this during "share your skills" training.

"We know our stuff!" they cry.

Of course they do. That is why they have been asked to run the workshop!

But the more you prepare, the more confident you feel!

So what is there to prepare?

This list will give you some idea:

- The scope of the workshop
- The sequence of the workshop
- The venue
- Promotional materials
- The student information package
- Student materials
- Your demonstration materials
- Extra resources
- Visual aids
- First aid kit
- Make a checklist of everything you need
- Pack your materials safely
- Time sheet with the running order for the day and times for breaks.
- Your content
- Practise your workshop in real time. Aloud.

"What! I" hear you cry. Practise the workshop in real time?

Yes. The first time you are running a workshop, practise it in real time.

Practise getting the things out of your bags and setting up.

Setting up may take you twice as long as you thought. For example, in a felting demonstration, you may find that you need

to put the water on your right if the demonstration is to be perfect.

You need to ensure that your checklists are complete.

Practice will ensure that you don't leave something at home that you need for the demonstration.

Practise delivering the information.

You will discover where you need to refer to your notes, and if you need to explain things in a better way. You will see if your timing works.

Run a pilot if possible.

If you can get a friend or family member or a small group to be guinea pigs, all the better, because their feedback will be invaluable.

You will find out things you didn't know that you didn't know. Usually that things will take longer than you imagined they would. This group will certainly help you to iron out the wrinkles in your teaching, and you will be so much better prepared.

Setting up the workshop

Resources:

The actual tools and equipment that you need depends on what you are teaching, but make sure you have enough for everyone. If students have to share, that wastes time.

If you expect students to bring their own, make sure the list is clear and complete. It is important to explain exactly what they need. If the students have never felted before, they may not

know what is meant by "roving," for example.

You should also have a good supply of:

- Pens
- Paper
- Towels
- Cleaning wipes

Give the students a list in their notes which includes information as to where they can buy supplies.

Planning the space

When you select the venue, measure the space. Make sure you ask about the availability of desks/workstations.

Make a diagram of the venue and plan where the desks/workstations will be situated in order for the students to be able to see and work well. Check positions of powerpoints and windows.

Draw a floor plan.

If your workshop is in your studio or home, ensure that family and pets keep out of the space during the workshop. (Especially pets, in case of allergies.)

Resources

Make a checklist of all the resources you will need, and pack them in the reverse order that you will need them. That way, the first one can come out first.

Samples

Prepare all your samples ahead of time. On the day, make sure that any samples and other visual aids are ready, and can be easily reached in the order that you intend to use them.

Presentation

Think about how you will present your information. These days, you can use multimedia to help with your workshop. It's easy to link a laptop to a projector, but check everything ahead of time to make sure it works, and have a backup in case it doesn't.

Food and drink

Have water available for everyone, or, if working with electrical equipment, organise a water station, such as a table with a jug of water and plastic cups.

- Will you provide the morning and afternoon tea?
- Will you provide the lunch?
- Will all the students bring their own or bring a plate to share?
- Will you have tea or coffee available all day or only during specified breaks?
- Will they eat inside or outside?
- Will they eat in a designated space or in a kitchen?

The day before

- Check with the venue that all is in order for the following day.
- Pack your materials into the car or into your bags.
- Run through the workshop quickly.
- Check your checklists.
- Make nametags for your students (or make sure they have something on which to make their own tags.)
 - If there are handouts, make sure they are stapled together.

On the day

- Arrive an hour early to set up.
- Check that the power is working.
- Check that the toilet is unlocked
- Check that the equipment works
- Check that morning tea, lunch and afternoon tea arrangements are ready to go.
- Organise the workstations.
- Unpack your tools, equipment, visual aids and resources.
- Make sure that everyone has exactly the same materials and they are on the tables.
- Check your checklists
- Calm down, take deep breaths. It is going to be okay.

Running the workshop

Beginning the class

Now we come to the workshop itself. How do we make sure that it runs smoothly?

To be an effective trainer, you must have the trust and confidence of your students. They must know that they are in safe hands.

After you have done your preparation and ensured everything is in place and ready, you should try to relax and enjoy the day.

It is important that your students feel welcome when they arrive and find the learning experience both enjoyable and beneficial. You want them to leave having learned new arts and crafts skills as well as meeting new contacts and possibly finding friends who share their own interests.

Welcome the students as they arrive.

If you have set up early, you should be ready to welcome the students as they arrive and hand out name tags.

Introduce yourself briefly

You should say who you are, how long you have been working in the area, and your expertise in the topic at hand.

"Hello, I'm Mary Smith. I've been felting for 10 years, but last year came upon this really interesting technique, and that is what we will be learning today."

This sort of very brief introduction makes sure that your students trust you. You get to say more about yourself later.

Go through the housekeeping

- Where they should sit/ place their bags and materials.
- Where the toilets are.
- The schedule for the day - when the breaks will be (and stick to this.)
- Hand out the students' welcome pack (all the handouts – they are listed in the resources section at the back of the book.)

Introductions

To get the most out of the workshop, students should feel comfortable in each others' company, so you should get the students to introduce themselves, wearing their nametags. I like to encourage students as they arrive to make or decorate their nametag. They can draw something on it that means something to them, or write a word or phrase that is important to them. Then, when they introduce themselves, they can explain the thing that they have drawn or written. It also keeps them occupied while others are arriving, or you are waiting for stragglers.

I also ask them to say what they want to get out of the workshop. Often, if their goals are in line with the goals of the workshop, I write that in a couple of words on a whiteboard or butchers'

paper (and I point out the goals as I cover them in the workshop.)

If their goals are not the goals of the workshop, you can suggest that you could run another workshop to fulfill those goals.

Your story

When it is your turn (last) tell your story. Say how you got to this point. Use humour and emotion. Tell them about how you started and how you learned your craft. If you are self taught then that's fine. It allows the group to have confidence that they could also be as competent as you one day.

Tell them as much as you feel comfortable with about your working methods and your inspiration. Why do you do what you do? How do you want to help people?

If you have any clients, collaborators or colleagues that people may have heard of, then mention them. It's not name dropping, so don't worry about that. People like to feel part of a group, and you are, in a sense, inviting them to join the group to which you belong. If there are others who have some credibility in the group, then that makes the students feel even more special. It isn't about making you look good. It's about making them feel good. And that's what the best workshops do.

You don't have to talk for very long – aim for maybe 5 minutes– but this introduction is important because it will make the group feel at ease, and feel as if they are in safe hands. If you want to run a competition or book giveaway then this is the time to tell them about it.

Icebreakers (optional)

There are lots of icebreaker activities which you can use, and often you can do something which is connected to the art or craft

that you will be teaching. If I am teaching writing, I sometimes get the students to play a word game at this point. If they will be breaking up into groups later, I get them to play in their groups so that the groups bond. So use your imagination and find icebreakers that fit with your theme or creative discipline.

Photograph it!

Take lots of photos.

Ask attendees if they mind if you add photos of them to your author page/blog/site/ facebook page.

Make sure you have their e-mail addresses to let them know when the photos are live.

Train like a train

Be organised – and let your students know what is going to happen, too.

At the start of the class, tell them and show them what they will achieve by the end of the workshop. State the objectives:

This is the train to Wollongong.

Go towards that goal, station by station. Announce the stations as you reach them:

The next station is Waterfall. We are now at Waterfall.

The next station is Helensburgh. This is Helensburgh station.

Keep on track. Do not deviate, even for the most persistent questioner. You will receive queries from your audience that will provide for some minor wandering off topic but you must be able

to steer the material back to the original content.

If you are tempted to waste time explaining something that is not on your "must know" or "should know" list, stop yourself. Say that you will cover it if there is time at the end.

Let them know – clearly – that they have arrived;

We have now reached Wollongong.

Recap the journey. Have a strong finish. A strong finish is needed for any delivery to be successful.

You must be able to summarise, restate and clarify the entire lesson in a concise manner. It's always good to re-visit the essentials.

The art of teaching

The "art" part of teaching — teaching anything, not just craft — is about YOU and your approach to your students. There are some people who are natural teachers. They do it intuitively, and it's easy to learn from them. You get the feeling that they know their subject, speak well, and care about their students.

But just because you know your subject or speak well or care about your students, does not make you a good teacher.

It's about combining all three.

When you are planning your workshop, always keep the students in mind, and also share your passion for the craft. Share your enthusiasm. If you are excited to teach, it is more likely that the students will be excited to learn.

Tips and tricks for teaching

Ask everyone to look at you before you start.

Ask them to put down anything they have in their hands, such as brushes etc. Do not speak until everyone is looking at you without anything in their hands. If anyone is speaking do not speak – wait till everyone is attentive.

Have an agenda in a visual form

Either on a chalkboard, or handout.

Walk around and help each person to achieve success in each segment.

Ask questions – does anyone need any assistance? Go around and help individuals but do not do any of the work for them unless they ask you to. It's best to demonstrate what you want to show them on a "demonstration" piece which you carry round with you (a spare piece of canvas, needlefelting, embroidery etc.)

Don't go on to the next part of the demonstration until everyone has completed the previous task.

Then ask everyone to put down all supplies, brushes, etc. and get their attention before you demonstrate the next part.

Use humour.

It is really important that you are willing to have fun. Some people see this as a danger zone, that the students will go too far, or the humour will detract from the class.

Some trainers have so much fun, however, that they forget the needs of the students. Humour doesn't mean telling jokes or being a stand-up comedienne. It means relaxing, not taking yourself too seriously – and doing all of this while focussing on the time management, the content and the needs of the participants. It's sometimes easier said than done.

Creating a welcoming and happy environment keeps students interested and learning.

Don't expect too much.

Students are human. Just because you said it, doesn't mean that they will remember it. Also, just because they knew something 5 minutes ago, doesn't mean they remember it now. Be generous, be gentle, and be forgiving.

Give your best.

Your energy and your passion will go a long way to giving the students energy, and making them feel passionate about what they are doing. If you are not passionate about the topic, how can you expect your students to be passionate?

The energy in the room is YOUR responsibility. If it flags, it is up to you to revitalise it. Often, you can do that by changing the activity for a few minutes. It is important for you to control the level of energy – and passion – in the room. Always give your best.

Use your voice.

A monotonous voice is often very boring. Be conscious of how you use your voice. You can change the volume, the speed, the modulation or the tone. You can make things exciting or funny or amazing or cool, just by using your voice.

Music

Music is something you might like to consider as a background for the workshop, especially when the students are working. It can change the mood or the energy in the room. It can be relaxing or enervating, calm or joyous, and can reflect the nature of the task at hand.

Student problems.

Be aware that you may have student problems. A student may have a personal problem that is affecting their work or their attitude, or two students may have a personality clash or disagreement. It is important to be aware of your students and observe them carefully.

It is your job to handle difficult people and tense situations with diplomacy and tact. At the first available opportunity, take the student or students aside and ask if there is anything bothering them, and go from there.

Be gentle and understanding, but it may be necessary to move students to a different group, or let them be on their own for a while. With adults, most people are able to handle their own issues quite well.

The differences between teaching children and teaching adults.

Many crafting tutors have taught children sometime in their life. Running a workshop is not the same.

Children learn because you tell them that it is important. Adults choose to learn.

Your students have paid good money to learn from you.

When adults learn, they learn actively. They listen, and they try to incorporate what you are telling them into their life – and craft – experience. Take this into account as you teach. Often, a blank look is simply absorption time.

Adults respect challenges, enjoy discovery and deserve a professional standard of feedback.

Use stories in your teaching.

People relate to stories, so if you have a story that illustrates a point, tell it. I love hearing stories about previous students' successes - or failures, and knowing that I am not alone as a learner.

Be aware of jargon.

Explain what you mean carefully. I went to a weaving workshop once, and the very first thing the tutor went through was the names of all the bits and pieces on the loom.

However, she didn't insist on us using those names exclusively, and when I described the trouble I was having with the "wool-carrier thingy" she laughed and came to help me. It wasn't until after she had solved my problem that she reminded me it was called a boat shuttle.

Every craft has its own jargon. Just remember that the students may not be familiar with it.

Train as if...

The big day arrives. The day you have been planning for and thinking about and dreaming of. The day of your workshop.

You are nervous, but you've arranged all your supplies, you've

communicated with your students, you've prepared your workshop environment. You know your objectives and goals. You've thought about your students, your topic and the techniques you'll use to teach the material.

You're going to be awesome, your class is going to be awesome, everything is going to be awesome... Until it isn't.

BUT... if something does go wrong on the day of the workshop, **only you really know**.

Train **as if** it was supposed to happen that way. If the demonstration doesn't turn out exactly as you planned, laugh and say that sometimes things go wrong if we forget about 'x', and if they do, we try again. Then, if there is time, do it again, and show that it didn't faze you. If there's no time, show them one of the "prepared earlier" examples, and carry on.

Most of us learn at least as much from mistakes that we make, or that others make, as we do from when we get it right — sometimes even more so. So show them what went wrong and why, and carry on. It will make the students feel more relaxed, more confident that even if they make mistakes they can still get it right.

If something else goes wrong – the powerpoint doesn't work, for example, –find your print-outs and hold them up instead. Don't panic, just keep calm and carry on – with a smile.

Know yourself.

You are the only person who can know what your reactions are. Try to identify any traits you have that could spoil the atmosphere of the workshop.

If you tend to panic, learn how to control the panic for the time of

the workshop. Go to the loo, breathe now, panic later.

If you get confused easily or forget things, write instructions down for yourself.

If you get led off track easily, put up a time sheet for the day and refer to it constantly.

Stay composed. Have fun.

Saying no

Often, students will try to sidetrack you and you may be tempted to go down that track. It is useful to have some answers ready:

"I'd love to cover that. I might do another workshop on that topic if you'd be interested."

"We don't have time for that today, but maybe at another time…"

"I'll say something about that at the end, if there is enough time."

Some students will try to monopolise your time. Here are some answers for that:

"If everyone is to get help, I'll have to move on, now."

"Do the best you can. I'll have a look soon."

"I'll just check the others now and come back to see how you are doing."

Or pick a student who is "getting it," or who has finished quickly, and ask that student to give the other student some help.

"Susan, you seem to have this under control. Could you spare three or four minutes to help Jean?"

Sometimes you will be asked questions that you don't know the answer to. If you don't know the answer to a question – admit it.

Maybe someone else in the room knows. Ask them. A class of crafty adults often will contain someone with that expertise.

If you say that you will look it up and get back to them, don't forget to do that. Write the question down on your follow-up sheet, and follow it up. Your students will love you for that.

Teaching style

Your approach to teaching is as important as what you teach. Everyone has their own teaching style, because it is linked to their personality. It is through the way you teach that you can communicate how much you care about your students and how much you care about your topic. It is how you communicate your passion.

Some people, as we have said, are natural teachers. For others, this approach has to be learned. However, it *can* be learned –and practised.

If you, in your own way, communicate to the class how much you love what you do, and show them care and consideration and respect, you will create an experience that they will remember with warmth.

Students want to have your approval, encouragement and support.

54

It is often draining and exhausting to keep up a constant engagement with the students, but it is worthwhile, because they will really appreciate your real involvement with their creative efforts and their personal struggles.

Teaching is nurturing. Students need to know that their success is important to you. Sometimes students will need extra help, and you could offer that in the breaks or at the end of the day, if circumstances permit. Sometimes all you can do is hold their hand when they cry because they feel they can't master the skill. If they know you really care, that's what's important.

Ending the class

The conclusion of the class is a big deal. It's the last thing that people will remember, their last impression of you. Don't let time run out before you do your "ending."

Take a few minutes to summarise the workshop.

Congratulate people on what they have achieved.

Encourage them to continue.

You need to leave them thrilled with what they have achieved, and excited about what comes next.

Show that you have covered all their goals for the workshop (if you wrote them at the start.) Make sure you did!

Get their feedback about the class.

Pitch your next workshop. Pitch your books or courses. If you had a book giveaway, announce the winner.

Get everyone to display their work on a central table, or around

the room, and have everyone come and look at it.

Maybe show each piece of work one by one, and ask for positive comments (no negative comments.)

Go out with a smile.

Testimonials

What others say about you is more important than what you say about yourself, so gather testimonials before the students leave.

You can ask them if they would be willing to record what they thought about the workshop, then flip on the camera or the phone, and record them.

After the workshop

Self-assessment

Accurate self-assessment means knowing your strengths and weaknesses. You won't be able to improve your workshops if you don't take into account what it was that you did right, and what it was that you did wrong.

Firstly, write down anything that you know went wrong, anything that you know you must improve for next time.

Analyse why you think it went wrong and what you need to change.

Did your students finish? Whether or not your students finish their projects within the given timeframe is important because it reflects how much they feel they achieved.

If they didn't finish, perhaps you tried to put too much content into the class, or perhaps there was not enough time, or wriggle room.

Go through the feedback forms.

Look at the comments and make 3 lists: the good ones, the neutral ones, the criticisms.

Ponder the good comments. In the next workshop purposely do more of whatever people mentioned in them.

Don't dismiss any comments. Don't defend your work by saying that they didn't 'get it'. If they didn't get it, that should tell you something. It's very important to be willing to listen to the negatives and consider them carefully. Maybe the only comments to dismiss are the good ones from your friends.

Think back over the class.

Were the students fidgeting, distracted, or always finished early, or yawning, or were they engaged? If the students are constantly chatting with each other, they are not fully engaged. Make a note of this for looking at next time.

Look again at your objectives.

Did you reach them? Were your students able to reach the objectives? Did all of them get there? If not, why was that?

If there were any objectives that students didn't reach, make a note to clarify the process next time. Maybe you need to change the materials or the method you use, or change the arrangement of the classroom, or how much time you allow for the activity.

Make a list of changes that you want to make to the workshop next time you run it, and attach the list to your workshop notes.

Next time you run the class, it will be better because of the changes you will make.

Follow up.

Put the photos from the workshop up on the facebook page or the website.

Research any questions that were asked that you said you would research. Don't forget the topics that you promised to get back to the students about.

Email all the students:

- Thank them for coming.
- Invite them to share any photos they took.
- Direct them to the photos on the website.
- Answer the questions that were asked in the class that you promised you would respond to later. Let all the students have the answers, not only the students who asked. Others may be interested, too, and you want to show all the students that you care about their questions and that you keep your promises.
- If you have books or upcoming workshops, let them know about how to keep in contact.

Add the students' emails to your mailing list.

Learning styles

Different people learn in different ways. These different ways are called "learning styles." Many theorists have a lot to say about learning styles, and there are too many variations to go into here. I'm just going to give you the top four.

This chapter will alert you to the different ways that students learn. With that knowledge, you can vary your workshop so there is something for everyone.

This is a summary of the major theoretical positions on learning styles.

Honey and Mumford

Honey and Mumford claim that there are four parts to learning:

- Having an experience
- Reflecting on it
- Drawing conclusions (theorising)
- Putting theory into practice to see what happens

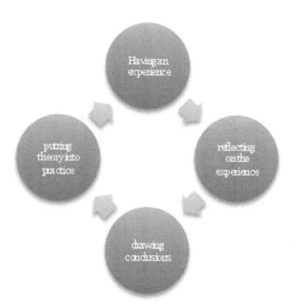

You can see this as a circle, so students can move around it as many times as they want or need until they have assimilated the learning.

They say that there are 4 types of learners:

Reflectors - Prefer to learn from activities that allow them to watch, think, and review. They like time to think about what has happened. They like to use journals and brainstorming. They find lectures helpful if they provide expert explanations and analysis.

Theorists - Prefer to think problems through in a step-by-step manner. They like lectures, analogies, systems, case studies, models, and readings. They find that talking with experts is normally not helpful.

Pragmatists - Prefer to apply new learnings to actual practice to see if they work. They like laboratories, field work, and observations. They enjoy feedback, coaching, and obvious links between the task-on-hand and a problem.

Activists - Prefer the challenges of new experiences, involvement with others, assimilation and role-playing. They thrive on anything new, problem solving, and small group discussions.

VAK

This stands for **Visual, Auditory, Kinaesthetic**, and represents certain learning style preferences in students. It is a simple way of thinking about learning. To make sure all our students learn, we have to present learning experiences that suit all preferences.

Auditory learners often talk as they work. They like to hear an explanation as to what will happen in the class, and they benefit from clear instructions and a good summary.

Visual learners can learn from the written word or from watching. It's good to have clear notes for these people, and to demonstrate what you want them to do.

Kinaesthetic learners do best while touching and moving. When listening to instructions, it's good for them to take notes. They enjoy getting into the activities and actually doing the work. That's when they learn most. If you have a lot of explaining, give the kinaesthetic learners plenty of breaks.

Myers Briggs

This model sees learning styles as 4 continuums.

1. Extroversion (E) versus Introversion (I)

Introverts find energy in the inner world of ideas, concepts, and abstractions. They concentrate and tend to be reflective thinkers. They think more than talk.

Extroverts prefer interaction with others, and tend to be action-oriented. They talk more than listen. Extroverted learners learn by teaching others.

2. Sensing (S) versus iNtuition (N)

Sensing people choose to rely on their five senses. They are detail-oriented, they want facts, and they trust them.

Intuitive people trust hunches ("sixth" sense) and their intuition and look for the "big picture." They also value imagination and innovation.

3. Thinking (T) versus Feeling (F)

Thinkers decide things based on analysis, logic, and principle. They naturally see flaws and tend to be critical. Thinking learners prefer clear goals and objectives.

Feelers value empathy and harmony. Feeling learners enjoy the small group exercises, especially harmonious groups.

4. Judging (J) versus Perceiving (P)

Judging people are decisive, self-starters and are self-regimented. They focus on completing the task, knowing the essentials, and they take action quickly.

Perceptive learners are curious, adaptable, and spontaneous. They start many tasks, want to know everything about each task, and often find it difficult to complete a task.

Howard Gardner's Multiple Intelligences

Gardner suggests that we have many different types of intelligence. Some of these are:

Verbal Linguistic learners like activities that involve hearing, listening, and impromptu or formal speaking

Logical-mathematical learners enjoy activities that involve abstract symbols/formulas, calculation, and problem solving.

Musical learners enjoy activities that involve music.

Spatial learners love activities that involve art, patterns/designs, colour schemes, and active imagination.

Bodily Kinaesthetic learners use activities that involve role-playing, physical exercise, and body language.

Interpersonal learners enjoy bouncing ideas off others. They love group projects.

Intrapersonal learners like silent reflection methods, thinking strategies, and concentration.

Naturalist learners like activities that involve bringing the outdoors into the class, and relating to the natural world.

This gives you a summarised and considerably simplified overall idea of the four main schools of thought on learning styles.

The top theorists can't agree, so where does that leave the poor person who has to run the workshop?

What it means for us, is that we must be aware that people are different and learn differently. It's important to present the material in lots of different ways, so that all students will have some way of grasping it.

Also, if you recognise your own learning style, you will be more careful not to force your way of learning onto others. The more styles you accommodate, the easier your students will learn. This is because you'll be concentrating on their needs, rather than yours. Also, material presented in a variety of ways keeps the learners interested and is less boring.

The business side of running a workshop

The first thing you may have to decide is whether or not you want to make your teaching into a real business.

You may already have a business, and running workshops may be a branch of that. If you are starting up a new business, however, you may need to check out the local laws about starting a business, such as registering it, getting a business number etc. If you are registered as a business, you will have to keep good records of your income, and pay your income tax if necessary.

How much do I charge?

One of the first things you will have to do, whether or not your workshops are part of a business, is to decide what to charge.

• Look at the prices everyone else is charging. You need to be competitive with other courses available.
• Calculate your costs – hiring the venue, electricity etc. (there is a cost-calculation chart in the resources section.) Once you have calculated your cost per student, that is your minimum. After that

you can take other factors into consideration, such as how much you want to earn, etc.

• As a rule of thumb you should be able to price your sessions so that roughly one third to one half of the amount will cover your costs and the remainder is profit.

Creative strategies for charging:

Some artists create a pay-what-you-like short course, which allows all students to come along and experience what you offer. Offering a pay-what-you-can scheme is not generally a problem in terms of students taking advantage of you, because they really want to be there and typically pay the most that they can.

Some artists like to offer exclusive classes at premium prices for people who want to work closely with them. This may include being part of your creative process in some way, working with you while watching you finish a commission piece for them, or maybe even hosting an event in their home.

How do I handle bookings?

When accepting bookings, you should have a booking form ready for the students, which asks for their name, address, phone and email, and any other information that you need them to provide.

It should also give them some information about the course, when payment is due, and how they can pay. It is a very good idea to have a non-refundable deposit which should cover the cost of the course for that student. That way, if they don't attend, you are not out of pocket for their share of materials, venue cost etc. You can do this through direct deposit into your bank account, or by paypal to make it easier for them to pay.

In your records you should make sure you have their full contact details, and how much students have paid. (See the booking

sheets at the end of the book.)

Your booking sheets will also help you with your tax.

Put your legals in place.

It is important to consider local laws and guidelines when it comes to teaching workshops from home – or in a hired venue – particularly insurance, and what is covered in case someone falls on your property or in your workshop.

You might also have to take out trades' insurance, which can cover loss or liability relating to your tools and workshop.

You could also take out insurance to cover loss of income resulting from illness, or cancellation of the workshop – and you should make sure that you are covered if you transport equipment and materials to other locations.

Find out if there are any laws or restrictions regarding the type of business that you can run from your home and if you have to notify any local officials.

If you are using a room in your own home, consider whether your household insurance will cover any loss or damage to equipment, tools and stock. Maybe you'll have to add these to your policy.

Search out the best deal to meet your individual needs and make sure you read through all the paperwork, so that you are aware of any exclusions. A good accountant can help you, and make sure that you follow the law regarding taxation, too.

Sales and Marketing.

When you list your courses anywhere, or make flyers, don't leave out any information. There is a course information checklist at the end of the book that you should follow when marketing your course. These are the things that must be included in any marketing information:

- descriptions of projects to be completed on the day
- what will be provided in terms of tools and materials
- the venue (entering the correct full post code for the location will enable a map to be displayed in many online listings and email.)
- date
- time
- the cost of booking a place
- any terms and conditions
- expected number of attendees
- your contact info, phone, email

You can place your workshop listings in many places.

- Craft magazines often list upcoming workshops.
- Local craft shops are often happy to have your flyers or put up a poster. Some shops have email lists for their clients, and may be willing to include your information.
- Start a facebook event.
- Advertise through local women's networking organisations.
- Leave flyers in local shops and craft venues.
- Craft websites may be willing to list your courses.
- Newsletters of arts and artist organisations could be happy to

include your event.

- Leave flyers or put up a poster in:
 - recreation centres
 - arts centres
 - art schools
 - cafes
 - community galleries and performance spaces
- Consider advertising in senior or retirement centres. Many retirees have disposable income and are interested in exploring their creative sides.

The possibilities are endless.

How often do I run workshops?

Most good tutors – and that includes you – find that regular workshops are the best way to go. Once a month, or once every couple of months seems to be a good frequency.

You don't want to cut into your own artistic creative time too much, or find difficulty filling the workshops, or get out of practice, or have people forget about you. You have to balance all those factors when making your decision.

If you find that your students want regular classes, then you can always rethink and add classes to your repertoire.

Workshop Ethics

It is very important that you are honest with your students. You must be able to build their trust and hold to very high standards of integrity.

If students are bullying or otherwise harassing another student,

for example, it is your job to take a stand on this, to take the student aside and explain that the behaviour is unacceptable.

If you are teaching younger students or adolescents, it may be necessary to have a code of conduct sheet for them (and their parents) to sign before the class.

If you are concerned about plagiarism of your own work, you may need a photography policy.

Be aware of the environment, and set up recycling options for the students.

Beyond workshops

There are other possibilities that may appeal to you if you find that you love teaching workshops.

Create art in public.

- Cafes or coffee shops,
- hotel lobbies,
- malls
- restaurants

Sometimes the venue will pay you, and sometimes you can start on a voluntary basis.

If you are paid to let others watch you make art in public, then that's great! It's win/win for you and the establishment. They stand out from the crowd as a venue, you are able to get publicity. You also have the opportunity to sell your art.

Adult workshops aren't the only opportunity either. Consider the following options:

- Classes with toddlers
- Classes with children
- After-school classes with adolescents
- Workshops in libraries
- Night classes for beginners
- Guest teacher at schools and art schools
- Workshops for professional artists
- One-on-one mentoring
- Small classes for collectors
- Business retreats
- Residentials
- Weekend art retreats for self-rejuvenation
- Art-themed cruises

Once you start thinking about the possibilities, they grow and grow...

Your success is in your own hands.

Where to now?

If you have read this far, you will have a clear idea of the reasons people run workshops, and why it might be a good way for you to go with your art or craft.

You know what is required in order to prepare for a workshop. You know the ins and outs of running a workshop, and have a good idea how to go about it (with lots of tips). You know what you should do after a workshop. You have some idea of what makes students tick, and you will have thought about the business side of running workshops.

The next thing you have to do is make that decision. It is not so difficult. Then turn to the resources section and look at the checklists.

As you can see, there is one for just about everything.

So first, decide what you want to teach, then turn back to the chapter on what to do before a workshop... and go for it!

I have a very dear friend who was once my client. Let's call her

Chloe. She is a wonderful artist, and has a very gentle and caring temperament. Many of her friends had tried to convince her to start workshops and classes, but she wouldn't do it. We met at an event where we were introduced, and she made an appointment to see me the next week.

She had all the skills that her art-work required, and she had been a practising artist for twenty-odd years, with moderate success. However, she lacked the confidence and the know-how to teach those skills to others.

She was afraid that people wouldn't value her work, but it was clear that this was partly because she didn't value her own work. She felt that nobody would be interested in learning from her.

Her confidence was so low that she wasn't even game to approach galleries etc. with her artworks. Yet she was at a point in her life that she had to find a way to make some extra money. She was thinking of giving up her art – or cutting her art time down, in order to get a job.

Chloe and I sat down, and I ran through with her the basics of planning and running workshops. I gave her some tips, and we discussed the business side of things, which she had already looked at a little.

What she really needed was the confidence to go ahead and the basic how-to guidelines.

She spent some time planning, going through the checklists, and soon, she announced that she would start a class, once a week.

She was surprised at how quickly the class filled. After a month or so, she added another class, and then another. That was just over a year ago.

Chloe's popularity as a teacher just grew and grew. Her confidence/ competence circle just blossomed. She exhibited in local shows, and now galleries are approaching her.

She has held two exhibitions with other artists and has joined the local artists' trail. She now runs five classes a week, with a workshop a month on special techniques or in glorious places such as vineyards. This year she is taking a painting tour to Italy. I am thrilled that she is heaping success on success.

And you could do that too.

Just over a year ago, there was no way that she would have seen herself where she is now, but it just takes a little confidence and the impetus to take that first step. Let's hope that this book can give you that impetus.

You can do it! You have the art or craft skills. You want to do this, or you wouldn't have read this far. Take your destiny into your own hands and run with it. Share your skills.

You have everything to gain.

Resources: Checklists, Emails and Handouts

All checklists, emails and handouts should have your name, email and contact number on them.

Apart from the plagiarism aspect, it allows students to contact you at any time if they don't understand something.

I put all my handouts on my letterhead.

They should all be carefully edited because they are all a reflection on you. They show how professional you are, and you really want students – and anyone else who reads them – to know that you are a professional.

Final proofreading is also important. Have someone check them for spelling, grammar, syntax and punctuation.

Checklist 1: Resources

As you go through the practice for the workshop, list ALL the things you need to teach the workshop.

A. Materials

☐ Pens

☐ Paper

☐ Towels

☐ Cleaning wipes

☐

☐

☐

☐

☐

☐

☐

☐

☐

☐

☐

☐

☐

☐

☐

B. Notes and handouts

☐

☐

☐

☐

☐

☐

☐

C. Resources (computer, computer cables, dongle etc.)

☐

Checklist 2: Choosing a venue

Space:

☐ How big does the space have to be?
☐ Can the space be configured in the best way for my workshop?
☐ Is there storage for student's bags and coats?
☐ Is there plenty of space to display your own work?

Furniture:

☐ Are there enough tables/benches etc?
☐ Are the desks/workstations provided in the cost, and how many?
☐ Will you need to find more tables?

Facilities:

☐ Is it wheelchair accessible if it needs to be?
☐ Are there decent toilets?
☐ Are there places for students to wash their hands?
☐ Is there a first aid kit?
☐ Is there internet access?
☐ Is there phone reception?
☐ Are there enough power points? Do they work?
☐ Is there a projector /screen/ whiteboard?

Eating facilities:

☐ Is there a kitchen for food preparation?
☐ Are there nearby cafes or restaurants?
☐ Can food be delivered?
☐ Is there an area for eating in the venue?

Comfort/ Ambience:

☐ Does the venue feel comfortable?
☐ Does the venue feel welcoming?
☐ Is there adequate light?
☐ Is the space warm/cool enough?

Parking/ Public transport:

☐ Is there enough parking for the time required for the workshop?
☐ What parking alternatives are there?
☐ Is there parking for you?
☐ Can you park close enough for loading and unloading?
☐ How easy is it to get to the venue by public transport?

Payment:

☐ Is it affordable?
☐ How does the venue prefer to be paid?
☐ When do you have to pay?

Insurance:

☐ What insurance does the venue have?
☐ What insurance does the venue expect you to have?

Promotion:

☐ Will the venue help to promote the workshop?
☐ What advertising will the venue help you with?
☐ Do they have an email list?
☐ Can they distribute flyers?
☐ Can you put up a poster?

Accommodation:

☐ What accommodation is available in the area for distant students?
☐ What accommodation is available for you?

Security/ Keys:

☐ Is there adequate security?
☐ If the workshop is to be over more than one day, can you leave the room set up?
☐ Are there security instructions to note?
☐ How do you get the key?
☐ When and to where must you return it?
☐ Is there an alarm system? If so, what is the code?

Availability:

☐ Is the venue available when you need it?

Cleaning:

☐ Who is responsible for cleaning afterwards?

Checklist 3: Before the workshop

Make sure that you have covered all these issues:

☐ The scope of the workshop
☐ The sequence of the workshop
☐ The venue
☐ Promotional materials
☐ The student information package
☐ Student materials
☐ Your demonstration materials
☐ Extra resources
☐ Visual aids
☐ First aid kit
☐ Resources checklist
☐ Pack your materials safely
☐ Time sheet with the running order for the day and times for breaks.
☐ Your content
☐ Practise your workshop in real time. Aloud.

Checklist 4: The day before

☐ Check with the venue that all is in order for the following day.
☐ Pack your materials into the car or into your bags.
☐ Run through the workshop quickly.
☐ Check your checklists.
☐ Make nametags for your students (or make sure they have something on which to make their own tags.)
☐ If there are handouts, make sure they are stapled together.

Checklist 5: On the day

☐ Arrive an hour early to set up.
☐ Check that the power is working.
☐ Check that the toilet is unlocked
☐ Check that the equipment works
☐ Check that morning tea, lunch and afternoon tea arrangements are ready to go.
☐ Organise the workstations.
☐ Unpack your tools, equipment, visual aids and resources.
☐ Make sure that everyone has exactly the same materials and they are on the tables
☐ Check your checklists
☐ Calm down, take deep breaths. It is going to be okay.

Email for students : 1

Preliminary email about the workshop:

- Descriptions of projects to be completed on the day
- Date
- Time
- What will be provided in terms of tools and materials
- The venue
- o Address
- o Contact information
- o Entering the correct full post code for the location will enable a map to be displayed
- The cost of booking a place
- o Any terms and conditions
- Your phone number and email

Email for students: 2

Email with workshop instructions

1. What they will need to bring:

- Materials
- Tools
- Food
- Anything else

2. What arrangements you will make for those unable to provide certain items on the day. For example, if you are running a glass class that needs gas bottles, students who are flying in may need to make different arrangements from local students.

3. What time the workshop will start, what time it will finish.

4. Location of workshop and a map of how to get there.

5. Arrangements for payment.

6. Ask them to label all their tools etc.

Email for students: 3

Follow-up email after the workshop

- Thank them for coming
- Invite them to share any photos they took
- Direct them to the photos on the website
- Answer the questions that were asked in the class that you promised you would respond to later. Let all the students have the answers, not only the students who asked. Others may be interested, too, and you want to show all the students that you care about their questions and that you keep your promises.
- If you have books or upcoming workshops, let them know about how to keep in contact.

Handout for students: 1

List of terms:

Include all the specialist jargon that they will need to know.

-
-
-
-
-
-
-
-
-
-

Handout for students: 2

List of suppliers

If the students need to provide their own materials, it is useful to send this with the introductory email.

If you are providing the materials, you should distribute this with the instructional handouts.

Item	Supplier	Address and email

Handout for students: 3

Code of Conduct sheet

example:

A student must not intentionally or recklessly:

- disrupt or hinder any other student in their learning or practice;
- engage in any dishonest behaviour;
- do anything which may endanger the physical or mental health, safety or wellbeing of any student;
- vilify another person or class of persons because of the actual or perceived gender, gender identity, sexual orientation, race, marital or relationship status or religious beliefs or activities, disability or age of that person or class of persons;
- consume or distribute alcohol during the workshop;
- damage any work or property;
- Photograph another student's work without their permission.

I agree to the above.

I also agree that if I break the code of conduct, I may be excluded from the rest of the workshop (at the discretion of the tutor) with no reimbursement.

Any associated costs will be at my own expense.

Signature (or parent's signature if under legal age) _____

date_____

Handout for students: 4

Running sheet

This should outline what is going to happen during the workshop.

It should include a timeline showing all the breaks.

It often includes safety instructions.

Handout for students: 5

Summary of techniques

This outlines everything the students will learn in the workshop.

It is up to you whether you hand this out at the end or at the beginning.

It should list all the steps that the students should take to reach the objectives.

It should be written in as simple language as possible, and use numbers.

Students should be able to follow this at home to reproduce the workshop techniques.

Make sure that someone proofreads this, as it is a lasting reflection of how professional you are.

Booking Form for students:

name	
address	
email	
phone	
Information about the course	
cost	
When payment is due	
How to pay	

Booking record sheet for tutors

Student name	address	email	How much paid	

Feedback form

Adapt this form as you wish:

Name of workshop

Date

Questions about the workshop:

Did you enjoy the workshop? Yes/somewhat/no

Comments:

Did you learn what you needed to learn? Yes/somewhat/no

What did you enjoy most?

What could have been better?

Questions about the venue:

Was the venue okay? Yes/somewhat/no

Comments:

What could have been improved?

Any other comments?

Evaluation sheet

Adapt this sheet as required

What went wrong?	How could it improve?
Did the students finish? Yes/most/some/no	How could this improve?

List the comments from the feedback forms:		
Good comments	Neutral comments	Poor comments

Did you reach your objectives? Yes/most/some/no	
List the objectives you did not reach:	How can you improve this?
Changes I want to make:	

Cost Calculation Chart

You should consider how much you will be drawing as wages and how much profit you will need to reinvest in your business. Remember to also include costs such as marketing and insurance as well as putting money aside to pay your taxes.

Item	Cost
Initial outlay:	
Tools	
Equipment	
Demonstration materials	
If you are using your own home, electricity etc.	
other	

Per student costs (multiplied by the number of students)	
Materials	
Power	
Food and drink	
Your wages	
Wear and tear allowance	
Replacement of tools, equipment, resources	
Marketing	
Insurance	

Profit to invest in your business	
Total	
Divide the total by the number of students = cost of workshop	

Readiness checklist

- ☐ Do I have a sense of commitment to the students?
- ☐ Do I have the drive to achieve?
- ☐ Am I reasonably optimistic?
- ☐ Am I in control of my emotions?
- ☐ Do I know what my strengths and weaknesses are?
- ☐ Can I learn from experience?
- ☐ Am I open to feedback?
- ☐ Do I have a sense of humour?
- ☐ Can I listen well?
- ☐ Can I give others feedback?
- ☐ Can I identify what others need?
- ☐ Can I relate well to different people?
- ☐ Can I persuade people?
- ☐ Can I inspire people?
- ☐ Can I guide people?
- ☐ Can I lead by example?
- ☐ Can I promote a friendly and cooperative group?
- ☐ Do I like helping people?
- ☐ Can I fake it if I'm not confident?
- ☐ Do I want to share my skills with the world?

Marketing checklist

This is what to include in any marketing:

- ☐ descriptions of projects to be completed on the day
- ☐ what will be provided in terms of tools and materials
- ☐ the venue, (Entering the correct full post code for the location will enable a map to be displayed in many online listings and email)
- ☐ date
- ☐ time
- ☐ the cost of booking a place
- ☐ how to secure a place
- ☐ any terms and conditions
- ☐ expected number of attendees
- ☐ your contact info, phone, email.

Notes:

Printed in Great Britain
by Amazon